IN
PRAISE
OF
RUMI

Introduction by Regina Sara Ryan

HOHM PRESS ‒ PRESCOTT, ARIZONA

for
Yogi Ramsuratkumar
my
Shams

Introduction

All of this is babble.
 Is it poetry? No! It's trash
 throw it out, forget you read it.
Do you think you understand?
 Have you swum on the moon?
 Have you watched your own birth?
 Has the sun burnt you to a well-roasted ash?

* * *

Who Is Rumi?

This collection of selected works of some lesser-known Sufi poets is offered in praise of Rumi, perhaps the greatest mystical poet of all times, certainly the most prolific. His legacy to history includes over thirty-thousand verses addressed to the Divine Beloved who dwells within each being. Yet his poetry has an immediacy and passion which distinguishes it from the metaphysical, objective viewpoint of other seekers after Truth. For Rumi, the God who he had known forever and worshipped in his heart appeared to him in flesh, in the form of a mad, wandering dervish, Shamsi Tabriz. From their very first meeting the relationship was to prove fatal. Rumi, the once respected scholar, was so devastated by what he saw in the eyes of this beggar, Shams, that he literally abandoned himself at the dervish's feet. All the descriptions of love which he had previously discoursed about with such intellectual clarity were now recognized as empty and meaningless. Touched by love, his mind was obliterated in the fires of devotion that ravaged his body.

When, because of jealousy and intrigue, the Master, Shams, was compelled to leave the town, Rumi's longing reached frenzied proportions. His "divine madness" and God-intoxication expressed itself in the whirling dance which today has become synonomous with the term *dervish*. In this trance-like state he spoke thousands of couplets and quatrains reflecting the exultation and pain, the excrutiating longing for, and the sweet taste of union with, *Him*.

The poets represented in this collection were chosen for their resonance with the heart and soul of Rumi.

The Poetry

Where exactly does this poetry come from? This is not a question of geography, but of inspiration. What, or more precisely, Who is it that touches these poets, and draws from them such laments, such ecstatic speech, such erotic imagery?

And who are these poets — these Sufis, whose names and dates are worn away by the sands of the deserts in which they frequently wander, or blurred by the spilled wine they talk so freely about?

Certainly they are humans like us, for their words stand as witness. And yet the mood they invoke belongs to a domain that eludes precise location or description. Mystics and great lovers throughout the ages have tried to draw maps of this secret place, but the maps have always contained a warning — "Do not try to follow here by simply putting one foot in front of the other." Recall the words of Paul of Tarsus: "Eye has not seen, nor ear heard, nor has it entered into the heart of man, what things the Lord has prepared for those who love him." (1 Cor. 2.9) To enter into the realm of these lovers is a journey that is only made with wings.

Reading many of the selections in this small anthology one is struck with the sense that these poems were not so much written as prayed, or sung, like Rumi's were, in the whirl of adoration. But rather than being the prayers to be recited in the marketplace, the mosque, or the temple, these often sound more like the intimate whisperings of the bedchamber, or the secret converse of ancient friends who gather late into the night to drink wine as they laugh and cry at what the years have shown them, and what they have only glimpsed and still hunger to know. Yet these songs of the intoxicated friends and sleepless lovers contain a clarity of expression and a razor-sharp insight which, in its intense Reality, appears as madness to the worldly wise. Like the Hanged Man card in the Tarot, the genuine initiate, must be willing to speak the unpopular truth that, "Things are not as they seem." The world's wisdom may very likely need to be turned upside down.

The poems contained here often convey the feeling that they were written *through* the poet, rather than *by* the poet. The same voice that animates Rumi, that animates John of the Cross, that causes ecstatic bliss for Teresa or Julian of

Norwich, that wounds and enraptures Mirabai or Kabir, Ibn' Arabi, or George Herbert, is recognizable here. Despite the unique shades of love each of these offered, the reality of which they speak is universal. Only one who has known such intoxication, and longing, can speak of it the way these poets have. They themselves are literally *being written* by that which has possessed them. Only readers honest enough to admit their own insatiable hunger, saddened enough to admit their own grief, and innocent enough to let a madman, or madwoman, give them directions, will find anything here. "Men and women in love," says Kabir, "will understand this poem."

The Warnings

The casual reader is warned in advance. These are dangerous words. While the immediate effect of one or two of these verses may be only a pleasant feeling of warmth, like a glow around the heart, the effect of reading more of them is cumulative and may be extremely hazardous to what you consider "your health." They will most assuredly touch places within you that have been neglected for a very long time, or never touched at all.

Many men have I known, yet none has known me...never has one even knocked on this door...

And once touched, a hunger for more may be quickened. One may find oneself with an addiction that is very difficult to break.

The second warning is more imperative than the first. This chamber of love, of which these poets speak, is the place of supreme pleasure, *and* of deepest pain.

To have once had one's heart touched is to carry the scar of love, with no place for another. Perfect pleasure, perfect pain.

They have entered a room from which they will not return alive. *Ruin* is the only alternative — a ruin that literally makes them useless to the world as they left it. Now they are beggars, poor sinners, fools, slaves who have no life to call their own anymore. Even their bodies belong to the One,

the,

...something (that) has taken hold of me: a huge hand crushing all that I thought I knew — braincells, muscles, sinews, breasts and body...

With nothing left to lose they dare to weep in anguish, publicly; in private they are hopeless enough to complain unceasingly:

O cruel one, You Heartless, Headless, Arbitrary bestower of Boons...

to the One who has loved them, who has let His smile be glimpsed, and then has seemingly turned His face, constantly eluding their grasp.

Your robe brushes my arm as you pass by. I turn, always too slow, and am left with the glorious ache in my heart.

The imagery of these poems is often highly erotic. They speak of burning, of consummation, of interpenetration and total surrender, in words that embarrass both the poet and the reader. Such embarrassment is a powerful alchemical process, one which softens the walls of defense, making virgins of old and world-weary women and men. This is the poetry of transformation through love — the poetry of the mystical marriage that leaves not "two in one flesh," but *nothing* in a pile of ashes.

You say you see His shadow near me? Is that enough to stay where you will be dissolved beyond recognition?"

In Praise of Rumi

To praise Rumi is to look him in the eye, or at least to put oneself on the side of the road and wait, patiently wait, for him to pass. Do not be discouraged. Wait with these poems, allowing their blossoms to ripen into fruit by your careful attention.

To praise Rumi, the perfect devotee, is to honor the impulse to devotion that lies dormant or smouldering in your own heart. It is to bow down, unashamed, before that which

VIII

speaks to you of the Divine — your child, the awesome face of nature, the innocence of His lovers and friends.

To praise Rumi is to be willing to throw your life at the Beggar's feet, or to welcome the sword in the Master's hand as he prepares to sever your head. Let these poems warn you of the ruin that awaits those foolish enough to ask to know the secrets of Love.

These poems are invitations — on many levels. And like a formal invitation to the banquet of a King, they demand a response. And it will be exacted, so be alert.

Listen, in the distance,...his footsteps sound in the hall. They grow louder, more distinct. A perfume-scented breeze...ah. Leave now, before it...

Perhaps it is already too late.

Each night I think that you will leave me
Yet each night here you are again
no different than before,
only deeper within me.
Your outer jaw has penetrated
my skin, my bones, the follicles of my hair,
but your inner jaw
has torn apart my heart.
What is it that beats inside me now?
Only the rhythm of your blood
only the waves of the ocean
into which you have cast me.
Knowing not how to swim,
I am at peace,
drowning without choice
in these unknown waters
alone
bereft of all things
save this one gift
to be so emptied
as to become myself
the cup of longing
filled to the brim.

You have filled me.
Will you also empty me again,
drinking this wine
into which you have pressed me
that I may become only
the fire of holy blood
flowing through your heart?

Touching my breasts
you have awakened
something in me that has not yet known man.

Your touch on my lips,
your eyes in my eyes —
what am I to do with this chasm
that has opened within me
where once I lived,
you live
yet you are nothing, no one
so within me now lives
nothing that I know!

Through you
God touches me
at the sweet core
and changes
that which I was,
the rock of earth,
into the body of communion
to be taken or given
as you choose.

Many men have I known,
yet none has known me
never has one even knocked on this door
which you have pierced and entered
before I even thought
to lay a stone across the way against your coming.
What is it, that you offer me,
that my being opens,
as a tide turning,
as a flower's face
knowing the direction of the Sun?

Nothing can you give me.
Yet all my being
Opens
without thought of price
and gives itself to You.

Something has taken hold of me:
a huge hand
crushing
all that I thought I knew —
braincells, muscles, sinews
breasts and body,
all that I thought I am
is dying.
All that I know now,
or hope to know,
is You.
Without your breath here,
there is no air.
Without your heartbeat,
even my heart has forgotten
the rhythm of our small life.
Only your Life
breathes over me
like a wind
from home
to an exile.
In your face
I see a light
as of a far country
seen through the garden of despair.
That light reveals
flowers growing in this place.
I am so amazed:
where death is,
there flowers also grow.
Slowly, day by day,
their perfume
consumes
the odor of death
in which I walk
and looking through

the eye at the center
of the flower's face,
I see your land
where fires glow —
signals
to those who travel
and those who wait.

Am I now
wine
turned
to fire
blazing
in your cup?
You have not asked me here
— this I know.
No door have you opened to me.
Neither have I knocked.
It seems
I have been poured
into your wine glass
as by accident
or as one small piece
of some cosmic joke.
In the heat
of your breath
I have become
nothing that I know.
I am as liquid
on fire
vaporizing
at the touch of your mouth
even on the glass that holds me.
Where shall I go,
what shall become of me,
if you will not
drink me tonight?
So shall there be
no more despair:
only your lips eyes heart and skin
glowing
with the fire
that I feed
and then become
in You.

What are you making in me
that draws me from sleep
into the world of love?

All day I walk in a garden
flowered with the myriad visions
of your face
in every face.
The streets are full of you.
Water is the touch of your lips
on my mouth
and thirst has become
only another reminder
of longing for you.

Yesterday I saw a man
drunk with his wine-bottle
in his hand
kissing a woman in the rain,
Coarse and derelict
as they were,
still they held somewhere within
a memory of love.

Looking into a child's eyes
passing on a grey city walk,
I find your eyes:
fierce, beautiful with fire
and longing to be free.

When you went away,
I thought that I had lost you —
yet now
I find you everywhere.
Everything serves solely
as a reminder of you.

In the night,
while others sleep,
Your light in my heart
burns me awake.
Restless with the taste of you,
I am turning
as some trapped chrysalis
in the cocoon
of my own small self,
its small desires.
Slowly, these themselves
become my food.

Eating my way through my own heart,
perhaps I will find
the way to that deeper heart
where you live
free
in the bonds of God —
soaring,
diving into our hearts
as winged fire.

Walking in the rain
in a rose garden,
flowers bend
pouring out their cups.
I bow my head to them
and drink of You.

Even my anger belongs to you now.
Everything I have has been given
 to you.
Who did this?
All that is left is who I am
and now I find
that who I am
is only You.
"Scrape the surface off the lover,"
said Majnun,
"and you will find only the Beloved."
All that I am
is you.
Not that you are responsible for me,
but that I am responsible to be,
wholly,
that which I have become:
to love as you love,
to be as you are,
to let you breathe through me.

I never asked for this love,
I am crying out again —
this ever deeper wounding of my heart.
Whatever question I asked of You,
I never thought that it was this.
In the nights I am in bliss,
simply longing for You.
In the day the cracks in the heart
wear raw and open, weeping.
I cover my heart and its nakedness;
I cannot look at You.
Sometimes in the day or night
I rage,
Who are You
to call me so steadily
out of the world of sleep?
And then again I quiver at this arrogance,
that I should think You call.
But the heart rages not, and questions not.
Slowly, step by step.
the heart advances.

I am alone here,
with my heart,
and my own battle —
so I believed.
Yet slowly,
through the mists of our fears,
I see the many hearts advancing
moving sometimes imperceptibly
against the great weight of our monsters
making their ravenous meal
on the living bones
of our Master.

I see the hearts advancing,
preparing
in some rich field
glimpsed through this battle,
the flesh and wine of communion
from our own blood, breath, and bones.

My heart has gone from me
following You through some dark tunnel,
toward a radiant light,
so the heart calls to me
from afar.
But I am afraid.
How shall I know my way in this darkness,
without even my heart to guide me?
"Listen!" calls my heart.
"You will hear us — come quickly,
the colors of the fire blazing
in the walls of this tunnel
will heal your eyes.
Follow — come quickly!"
How shall I follow in this darkness?
I cry out,
stumbling,
as I feel with my hands
over the rocks
deeper into this closed chasm
where I am so alone
except for my heart and Your flute
heard afar off.
How shall I find my way in this darkness?
"Go back!"
shout those who watch
from the bright fields behind me,
who have never even peered into this tunnel,
or had their hearts wounded
by the undeniable note of Your flute.
"Go back!" they cry,
while my hands slip on the rocks,
wet with my tears,
and I clamber onward.
It is perhaps possible I could live
without the sound of Your flute —
but how could I live
without my heart?

Everything has become worship of You —
to touch Your mouth
to climb in the branches of the peach tree
swaying as the storm strikes its lightning
over the snow peaks of the mountains
to lie with You
as the sun dusts us with colors
in its rising
to weep alone
as the moon makes its way
past the planet mars and beyond venus,
into the realm of Orion,
where the warrior of God
seizes the heart for His own;
to rest in sweet surrender
as this fire consumes my body
leaving my unprotected heart
beating
held in Your hand.

All that there is,
is worship —
to wash Your feet,
like Magdalene,
with my hair;
to make of my heart's blood
sweet ointment for Your eyes,
to lie with You,
to lie alone,
to eat of the summer fruit
and remember the bitter hunger
when food fails us
in the winter storms —
all this is only worship,
only more deeply
knowing You.

I consider love dangerous.
For us, human beasts wounded
in some garden before Eden,
with the opening of love
comes vulnerability
to all its oppositions:
hate, envy, greed, possession;
and opening also
to the unplumbed depths of pain.
To remain in the twilight mediocrity
of a cool caring
is sometimes at the least a calculated wisdom.
Yet this cautious choice is no longer in me.
My heart is being widened
by some huge stretching hand,
as the cervix widens to give birth.
It begins so gradually —
I was not forewarned;
and sometimes while I was watching
the upper pastures for wolves,
the lower pastures also have been taken,
and the wolf is now within me,
gnawing at the moorings
with which I hold control
and direction of my heart.
Ah — so I still try to pretend,
comforting myself that in the face of the wolf's teeth,
for this moment I still hold the moorings
and may yet regain control of the wind.
Yes, the wind and the moorings
I may yet control again.
But they hold nothing;
for the heart is now with You.
While the wolf chews at the remains
of empty ropes and anchors,
the precious jewel of the heart
has gone with You.

And all the cold watchfires in me
burn alone.
Now instead the wolf
chews on my bones, my self,
gnawing at the empty, burning cavern
where the heart once lived.
"What more do You want from me?"
I cry out.
Sleep is gone from me.
All the normal fires of blood:
hunger, sleep, pain of the body,
these have gone out in me.
Now there is only
this one fire
growing —
the fire of You
that has ignited in me
and ravages the sweet, small home of self
where I had thought to live
with contentment (and with death).
I am awake in the night
fighting this fire
with the pale waters of reason
and my drawn sword, melting.
"My surrender to You is not complete!"
I shout.
"I have not chosen this,
nor have I been invited.
This is yet my land —
who gave You permission here?"
But a fire does not ask
whether the first spark
came by anybody's choice.
All that it knows is to burn.

The cup being offered
was finally accepted
and those who drink
now know the taste of love.

Why must words try to express the magic of love
How can they
where words fail
the eyes of a lover succeed
they mirror the beautiful anguish
of a heart aflame with love
to see such eyes is to see love itself
what more can I ask for

Oh Saqi
Who has lured me to this Tavern of Ruin
keep my cup full with your wine of love
that I may always revel in this ecstatic agony
and glimpse once again my Beloved

The Tavern sits waiting
for the time when friends will come
already drunk, and enjoy the
Presence and the Absence
and care for nothing else

Oh Saqi
May this Benediction be bestowed
upon us as we sit
friends united in longing.

A man in the shadows,
he beckons to me
and leads me to a door.
With a smile he shows me in.
An ordinary man
with a mischievous grin
and a wink.
He offers me a glass
and I drink.

Oh! What Trickery!
I do not care though.
Your wine merely increases my thirst
and You laugh.
And so I join the ranks of the insatiable,
Teetering on the brink of annihilation.
Your masterful hand allows no one too much
and we wait for caprice to shine.

Your eyes betray You,
I should have seen that.
Playful cupbearer
fill my goblet once again.

Oh Saqi, my eyes are clear
yet they cannot see but the line of your neck
or the hint of an eyelash.
I feel you as you glide through the Tavern of Ruin.
Your robe brushes my arm
as you pass by.
I turn, always too slow
and am left with the glorious ache in my heart.
I would beg,
but what right have I?
I would pray,
but what means have I?
I would love,
but how can I?

Oh Saqi,
the unknowable Beloved
dances in your eyes
and teases my heart.

Oh Saqi,
to see you as I would like
would sear my heart.
Such pain I would welcome.
You are the unknowable, the unspeakable.
I bow and beg for your mercy
as I search for the ghost
of the Tavern.

My eyes are clear
yet they cannot see but a wisp of hair,
a fold of a cloak.
Oh Saqi, to be graced with your love
seems unimaginable.
I can do nothing but bow before you
and sing my heart's song,
As once again
I turn too slowly.

Softly, silently
the veil is lowered.
Then, like the sharpest sword,
my heart rips the
veil apart.
Passion ignited,
I sit with the
ache of love
burning in my chest.
Majnun knew Your love
and Majnun was ruined.
To be so drunk
with no regard of tomorrow,
to see Layla in all
and never to touch
such perfect love
in Divine Separation.
Oh Capricious One!
Whose heart will You choose?

How can a full heart
keep its words in check?
Saqi, fill this cup again
that I might sing anew.
The Tavern of Ruin
empty or full is life and love for me.
My heart calls out to my Beloved
searching, waiting in blissful anguish.
Time? What worry is that of mine.
Tomorrow will come of its own.
Tonight — any night, is a night for lovers.
This shell of flesh
cannot conceal the light of my heart.
Let its light find my Beloved
laughing as He runs off again.
Oh Saqi, fill this cup again
that I might sing anew.

What is this which I attempt?
Pen in hand, I beckon with my words
the unimagined beauty of Your Presence.
Thou art what Thou must be.
Perfection.
And I with my faulted perception
stand in Your radiance,
scorched by Your intensity,
and inside seared by love.
I am all which Thou claims,
yet I am not.
The agony of my uncomprehension
draws lines of sorrow into my face.
You, my Beloved
are not as revered
as You deserve.
For this I shall
mourn endlessly.

We sit and wait
chasing shadows
yet never swaying.
Our task is great
but the result undescribable.

Considering matters unconsiderable,
lovers of the same One
Possessiveness, jealousy, are burned away
and the love becomes pure.
Beloved One, may my love some day
be such as this.

To dance and drink wine
Life from day to day, carefree?
Perhaps.
But perhaps it is a desperate dance
of feigned ecstacy.
A futile attempt to be happy.
And why? for what reasons?
To merely jump at freedom
like the Salmon who, tireless,
leaps from ledge to ledge
in a heroic journey upstream?
Or perhaps we are more like lemmings
running to our deaths
because of some inconceivable belief
that salvation will be found
in the flight toward oblivion.
I am fed up
with such useless carryings on.
I have heard your words
and now my dance seems
even more irresponsible.
Yet I continue,
possibly eternally,
though you say otherwise.
I carry the torch of sleep
like a royal banner
as I hurtle off the cliff
and go to my death
unquestioning.

To you the cup is given.
Drink of it deeply.
Share the nectar of Saqi
and wait with us drunkards
in the house of Ruin.

Joy cannot be felt
without sorrow,
pleasure without pain,
love without emptiness.
To have once had one's heart touched
is to carry the scar of love
with no place for another.
Perfect pleasure.
Perfect pain.

The corruption of love
comes in its expression.
The beauty of the heart
is disfigured
when words try to describe it.
Yet they must.
The heart begs to speak
and words are my medium.

Take this goblet from my lips,
for the fire which burns deep in my soul
wants none of the wine
which has fueled it thus far.

Begone! I wish isolation
to weep and wallow
in my senseless tragedy.
How can a man such as I
turn cold to a world as beautiful as Yours
and maliciously cut the flow of the milk
which feeds me?

The painful pleasure has driven me both to You
and away from You.
The balance will settle,
that I know,
and my love shall emerge the victor
for it far outweighs any feelings of animosity
which, though small, fight mightily
to tip the scales.

Though Your love may be capricious,
I feel at times my acceptance
or denial
is far more unpredictable.
For as I have finished this line
my loathing has turned
to the sweet ache of longing;
and the ashen taste in my mouth
is forgotten
in the swell of my heart.

I leave Your Presence and as in a dream
　　My feelings mute and I forget
　　　　My love, my devotion
Recede into a chasm of forgetfullness and ignorance.
I return
　　and suddenly like an explosion from within
My love
My devotion
　　hammer with irresistible force against my heart
And the pain of my sleep is highlighted
　　by Your brilliance
Oh Saqi
　　You are the light who drives the darkness from my soul
And I feel your excruciating grace in your every glance.

I am full of yearning.
I ask You to examine me.
I know my test is now.
Do not let me sleep, Beloved
do not let me rest
until I am with You.

I will give everything
to come to You.
I will do what is necessary.
Take me on.
Yes, You already did take me on,
so I give my yearning to You too.

Tell me what is necessary.
Yes, You have long since told me.

Why did you claim my heart
Before I'd given it myself?
Before it was mine to give.
And when, in this undoing, I could neither
Claim it nor give it,
When who I thought I was
Flashed and faded
In defective rhythm
And mind was stripped of knowing
And fled in terror from encompassing strangeness,
Why, when in my madness,
When mind betrayed heart,
And my heart belonged to You, not I,
Did You, in your arrogance or wisdom,
Return this heart to a shattered place
And replace her with another?

Now I have made claim
Of my self, my heart, my voice.
They are worthless to me.

I have been a guest in His Kingdom —
The banquet room of the King,
Only to be banished again and again
To the waiting room.
I have sat outside the door
And sit now to wait
For the invitation to remain inside.
Dregs of wine and scraps of feasts
Come to the one waiting outside —
They are like sweet poison,
Only a taste of the feast within,
Always reminding
Of the golden light,
Silver goblets and perfumed air,
The black ringlets of the King
Who favours His own with devastating glances.

I have been a guest in His Kingdom —
Even the inner sanctum of the Lover
Where He loved me on His rose-perfumed couch,
Only to be banished again and again
To the waiting room,
Until I grew bitter and ragged
With hopelessness that I could not stay,
And believed His promises
Made in the inner room
To be lies and folly.

The Tavern is the waiting room
To the banquet hall —
The King sits with us.
My heart is the waiting room to the inmost room
And I sit alone.

Slaves and cattle are branded
 to name ownership
My lover has branded me so that I am not mine
 but His.
His voice has branded my ear,
 His touch my skin
My eyes are blinded to all
 but His Form
My mouth has been reshaped
 by His Kiss
And would taste only
 His Sweetness.
When I do not breathe His Perfume
 the air is foul
My heart is branded with His Name
 and it cries out endlessly
Having been given freedom
 I burn and wait for Him to
 claim His Ownership.

My Beloved called me Lover once,
But it was not his pleasure to meet my desire,
Or his joy to calm my agitation or kiss my tears.
He wove shackles around my ankles,
Not shackles of silk that promised his touch,
But shackles of cold disdain that cut and bruised
And reminded only of promises broken and trysts forgotten.

My Beloved bound me to him once,
Each breath become a coil of yearning and sighs.
But it was not his desire to taste this breath;
His eyes followed other's eyes,
His mouth accepted other's kisses,
His body joined other's yearnings
And left this lover to wait too long
When desire unmet becomes a flood
Obscuring yearning with unfruitful agony.

My Beloved touched my heart once,
But left it bleeding,
And each drop of blood tasted bitter and of poison
Until this lover learned to tenderly distill
Each falling drop into a poem or a prayer
To taste His Sweetness once again.

Oh Beloved! In Your infinite Wealth
 cede this beggar Your Poverty
For in Your riches how easy
 it is to forget.
Yet to be a pauper full of longing.
 how sweet would be this pain.

Friends of my heart,
 Does your hair dance
Do your eyes swim with tears
 Do your toes sigh as you sleep?
Pray for this unworthy fool,
 who's hair falls disheveled
 who's eyes remain dry
 who's toes are quite still.
Beloveds of God,
 Fly, exalted souls
 fly for this poor sinner
 who may never rise but for you.

Silence stinks!
Words cannot but fail.
Dance is boring.
Solitude is useless.
Company is painful.
God?
Hah, hah, the joke's on you.

Back straight. Back crooked.
Eyes open, Eyes closed.
Are you seeking God?
Why?
Is your body seeking God?
A bit wiser.
Who are you? What are you?
Never mind. Just be grateful you're capable of farting.

Beloved, Beloved
 I have called Your 99 Names
 yet none of Your names touches
 the beauty of Your face

Beloved, Beloved
 When will I see you?
 These words of You only make me
 famished for the taste of Your tears

Beloved, Beloved
 Distance from Your thought and touch
 only show me how hollow is life
 without You

Beloved Lord, King, Master, Capricious Slave
 I will serve You
 even if You keep Your face
 from my burning eyes

Beloved, Beloved
 Who is this that thinks he can serve You?
 An undeserving mite, an atom, a speck of dust
 who longs to be burnt in
 the furnace of Your Whim

Beloved, Beloved
 My pleasure is in the calling
 I don't need to wait
 for an answer

Beloved, Beloved
 I have a fantastic dream
 to be slain by Your Glance
 a worthy dream

Beloved God, Divine Majesty, Power, Glory
　　What has given me the arrogance to talk to You?
　　The Zephyr that has carried Your perfume
　　　　having lost my senses in
　　　　drunken intoxication

Beloved, Beloved,
　　I cry "shame" to call on the Lord like this
　　But my heart has melted and
　　　　I know no shame.

The holidays are over. Yes, yes,
 they were wonderful and full.
Now it is just winter again.
Where has it all gone, my Lord?
In the beginning You showed me much
 I lived by Your Word
I was strong and bent before no one
Now I am weak, a coward
 full of misery and self-reproach
Then I saw clearly, no clouds
 Now I see clearly, no clouds
But Your lovers suffer such anguish
 and dream, only dream of joy
Must I like this pain I feel because of You?
 I cannot love You in so much pain
It is true I must be the lowest of beggars
 to be so ungrateful
 to accuse You like this
My complaints are so many
 What an affront to the One
 Who has given so much
I am bent to Your Will, oh Beloved
 and such a miserable worm, moaning
 when he should acclaim Your Glory to all
If it pleases You to have me grovel
 Well then show me Your feet
 that I may place my neck beneath them
 Show me Your face
 that I may be blinded by one glance
 Show me Your hair
 that I may be ashamed to have
 imagined stroking it

Beloved, I will sing of You
 whether my song is one of complaint
 or one of praise and delight
Only You, Beloved
Only You.

Oh Lord, You have given me wealth
 You have shown me the world, given me health and
 freedom to chase every rainbow
Beloved, You have given me sight, hearing, smell
 with which to enjoy Your endless Creation
Then You whispered Reality in my ear!
 I thought "Now I will be Free, since God
 has given me His Secrets."
But one by one, Your Secrets dissolved
 They crumbled into the dust
 from the clay they were made of
So I thought, "Now I will enjoy God's Trust
 since He has relieved me of all
 this distraction"
And You showed me life is empty
 without loving You
And You showed me I could not Love You
 only Your Whim could
 affect this love
Oh Beloved You cruel One
 You Heartless, Headless, Arbitrary
 bestower of Boons
I weep only to be Your slave.

Why do you wish to be my friends?
 Are you happy, full of life?
 Are you free of pain and attachment?
What? Whisper that again!
 You smell the odor of God you say?
 You must be mistaken. I smell nothing.
You say you see His shadow near me?
 Is that enough to stay where you will be
 dissolved beyond recognition?
You know enough to know that
 where there is a shadow
 there must be the One Who casts it.
So you think I am such a fool?
 Can't you see what a beaten slave is here?
 What makes you think this is so easy?
Why do you persist my dearests?
 Pray for this pauper so he may
 feel some gratitude for your trust
 instead of enmity, you liars and thieves
Pray to our Beloved for this madman
 fold your hands over your hearts
 and die.

So, I say;
 You want God?
 You want Bliss?
 You want Life?
What is it worth to you, eh?
 Your health?
 Your peace of mind?
 Your equanimity?
 Your sanity?
If you want to imagine Him,
 you may get away with it inexpensively:
 act like your mind is full
 and like your voice is angelic
If you want to remain asleep,
 call everyone Brother or Sister
 touch their arm, rub their back
 avoid their glance
But! If you want to meet the Creator face to face,
 Ah! be prepared to be misunderstood
 ostracized by your friends
 flushed down the toilet of the "world"
Well, I mislead you
 You cannot be prepared
 Only no preparation is preparation
All of this is babble.
 Is it poetry? No! It's trash.
 throw it out, forget you read it.
Do you think you understand?
 Have you swum on the moon?
 Have you watched your own birth?
 Has the sun burnt you to a well roasted ash?

So you think you will be full of wisdom
 when you realize Him?
 You will be a drunken fool.
 You will be a filthy pauper.
 You will be twisted and mad.
Of course if you still want the Lord,
 Then have Him if you wish.
 I will mourn you.

Beloved, wake me at night
 with Your laughter
If I ask for a restful sleep
 Ignore this thankless fool
Keep me awake all day
 with Your memory
As the stream caresses the stones
 smooth this beggar's sharpness
 with the rippling tones of Your voice
Beloved, I deny You with one breath,
 Breathe You with the next
 strike half of his breaths with Your sword
Beloved, if I must deny You
 let me deny you ceaselessly (how cunning)
Beloved, if I must breathe
 let me breathe only one breath
 and let it be You
My Lord! If speaking Your Name
 does not suit You, strike me dumb
But, Dearest, if speaking Your Name
 suits You, let me speak it once,
 never to leave my lips
Beloved, You are quite a businessman
 Let me beg for bread and water
 or fill my cup with Nectar
Beloved, I may nag You to my grave
 Hah, do You think You have fooled me?
I am well fooled, I cannot be fooled again.
So I do shout, even as this voice
 falls short of all ears. Hah.
 This nonsense is just a whisper.
Do You wish to hear a shout?
 Then have another fig.

Tell me Saqi,
 does Your wine free the revelers
 of pride and of 'face'?
Just look deep into the eyes
 into the depth of the souls of
 those who drink His Wares
Are they in drunken play
 with the frequenters of this lowly saloon?
But beware my friends,
 do not dare to enter this Tavern door
 unless you are willing to
 leave sobriety outside in the dust of the street.
These mad inebriates inside
 may knock you on the head and steal your purse
The door to this Tavern
 is not marked by a billboard outside
The road in front is well traveled
 but even though the door here is just at the street's edge
 there are few footprints on our mat
Oh! stranger. If you wish to be befriended
 by drunken fools, by louts, then enter boldly
If your logic is of value though,
 do not stray here.
They tell me Saqi,
 that You sell a very rich wine.
 its potency will enrapture me
 but I must drink of it evermore
 or the hangover will kill me.
Saqi invites you in
 He bedevils you and teases you
 into this riotous and ruinous place.
He sells a very rare wine.
 If you cease your drinking, if you fight
 this sure addiction, you will certainly
 reach Heaven or Hell

But if you remain drunk in this Tavern,
 blind with the other revelers,
 you will not know the release of either
But the Beloved will wink at you
 His reflection clear in the mirror
 of Saqi's wine
Saqi has forgone peace and ecstacy
 to pour wine
 The Friend has veiled the Kingdom
 from him so as to banish him to
 the Tavern as a lowly wine merchant
Saqi is surely a fool.

Beloved, this afternoon I am so full of pain,
 anguished in my soul.
My notebook was far away. The poetry I sought to write
 to You about suffering is all forgotten.
Now I feel light, full of a delicious meal.
 But while I suffered how I longed for mediocrity.
Now I despair this stagnation with disgust —
 Make me suffer or enrapture me with Your glance,
But don't let me forget You so easily.
You aren't just my stomach, are You?

Oh Beloved,
They believe the doctors, the lawyers, the scholars
while they slander You and turn Your words to mud
Oh Beloved,
They chase after the ghosts of the world of shadows
while seeing Your diamonds as no more than glass
Oh Beloved,
Try as You might to melt hearts of stone
they refuse Your Gift, for fool's gold of illusion
Oh Beloved,
Wrap them in Your blanket of Ruin, invite them into the
Tavern where Saqi will fill them with Wine and light the
blazing Fire of Love.

One day I was calling this agony delicious.
Another day I abhorred its burden.
One day I begged to shoulder a grain
 of the suffering of my Lord
Another day I begged for release.
But every day, no matter what my poor play,
 there is only the Lord.

Oh Beloved,
 Your court is so ragged, Beggars of every color cloth
 Your courtyard full of Hobos, crumpled
 into piles of flesh and clothes
 Disheveled beyond recognition:
 would their mothers know them now?
Oh Beloved,
 Your courtiers all so Foolish,
 postures surely those of knaves
 Your throne of gold quite hidden by ancient trash
 Trash made sacred by Your glance
Oh Beloved,
 A King of fabled lore, poverty is worn
 like robes of silk and rare fur
 A Kingdom long forgotten, only sought
 by those who are Mad
Oh Beloved,
 I have stumbled into Your Tavern,
 fallen flat into the gutters of
 the streets of Your domain
 Your Glory is too much to contemplate,
 let me be the lowest servant in Your
 Beggar's court.

If I speak nonsense,
 clap your hands, shout a prayer,
I will dance instead.

Rain pours a river,
 washing away cloudy dreams,
Leaving me stone clean.

Waiting for knowing,
 I periscope out my hope,
And watch shooting stars.

Who is he, this Friend?
 leading me to dark places
Handing me the flame?

Hearts bursting with deep
 sad-longing and too fragile
remembrance, we love.

I have no arms to grasp my friends,
nor eyes to see their smiles
or the sun.
I have no heart to feel love.
They are all buried and burned and destroyed.

Tears fall from the empty sockets
in my head
and this pen writes on its own.

I am helpless and drowning
in this ocean of confusion.
A fitting death for one
as lowly as I,
with such ambitions of love.

I am so far from home
and so tired of this journey.
Dust covers and penetrates my clothes,
my body is like the street,
dusty, dirty, rough, pitted and worn.
My throat is parched
and my eyes
are blinded by the sun.

All my water has been taken
by the Thief,
and Wine left in its place.
My horse has died,
I have fed on him
a few days ago.

I hear your voice
from amongst the shadows
of the dunes.
I walk aimlessly now,
driven mad by this life.
Nothing I can say
makes any difference now,
and the voice I hear
bids me come further into the dunes.

Suffering is not a question.

Suffering is the answer.

I turn from suffering
That I am offered.
I often seek the cure
for this suffering and take
myself away from God
the Physician.
What a curse.
Oh!!
How my cells burn
from the Fire of this suffering
and the smoke of the Fire
clouds my feeble mind.
How I long for a drop
of Your affection and tenderness
and yet shut the door
when I hear You coming
or see Your sandals.

Yesterday I was shattered
by the fragrance of a summer breeze.
I felt violated by the disturbance
of this storm. Inside of me all the
tables were turned, there was no
place to go. I was caught in the
trap, wildly chewing off the leg
that You held so lovingly and gently
in Your hand. I am a fool who doesn't
recognize his foolishness and mis-
takes it for his piousness.

Is there any hope for one
such as I? I think not.

You say come join me at my
table and break bread with me.
The lion lies down with the Lamb
of God.

Dancing in Madness,
eyes on fire
distant and burning.
Voices
from the dark side
breathing smoke and Fire.
Sweat and heat
backs arched
arms outstretched
never touching another.
In ecstasy
already merged.
Engulfed in darkness
bathed in luminous red
hearts pounding
Pushing to the edge
and more.
Out of time, Space
the vortex
Mad, abandoned dancing
Wild, passionate, whirling
clapping.
Inflamed, frenzied, chaos
on and on
building, stronger
faster,
Reaching for the end
which will never come
 never come
 never come
Endless madness
Spinning
heads back
insane laughter
minds gone
moving on and on
forever in a night.

The end never comes
The beginning never happened.
On and on, on and on .
on and on, on and on...

How can I love the one who takes everything
and leaves me out in that world to die?
How can I love the one I slaughter
as easily as I would turn my head?
Oh bitter world,
is it only through you
that I come to know myself;
to know the peace, beauty, and sweetness?
Then I love you;
I lower my head and love you.
I hide my face and love you.
Quick now,
off with my head
so there is none to lower,
none to hide,
and none to love.

Beloved, Like a tidal wave
You loom over my little house
so close that I can feel the salt spray
on my skin.

Like a tidal wave
ready to destroy me and all that is
built and preserved
called "my life"

In previous times I would run around
frantically boarding up
doors and windows

Today, my strategy is different:
acting nonchalant I keep the panic
under control

In amazed relief
and remorse I watch
as the wave curls in upon itself
and recedes back out to sea.

Come home into my heart
 Rest, sigh, take a breath
Your love for me is like a buoy
 in the roughest sea
You are my ground, my sustenance.

Even though I see now, so many things
 I've refused to do
I can also see that my arms, my love, my joy
 Are not enough for You
I pray mightily that with the help of other
 drunkards we can take You towards the
 heights that You so easefully and skillfully
 catapulted us to so often

Just the thought of Your touch
 thrusts me towards the heavens
Your friends make me soft and weak
 with laughter and joy
I have strained us, I have played my part
 in this Divine Crime
But all Your suffering will not be in vain —
 Not for naught
You are alive in the Tavern
 You pulse and beat the drum of Saqi
We hope to taste the gift of his Wine
 to bathe in Your laughter
 to drink of Your tears
and wallow in the drunkeness of Your love.

And so, my sweet Beggar King:
Did you think I would stop trying
to catch a glimpse of You?
If You changed into an owl
and sent me to play with colorful birds?

I eat you yet I suspect
I am the eaten one.
You are the Game Master.
I am not fooled by your rags
and your endless devices
in playing hide-and-seek.

It's all fine with me.
I'll play any game of yours as best I can.
Is this supposed to be what you call relationship?
I'll take whatever you're offering.
I see there's no resting in those Beggar's arms of yours.

The Robe

The tattered robe of the wine boy
Scraps, rags, fragments
 of the silks and velvets
 of the sheiks and sultans

Night after night
They come to the Tavern
 to smoke in camaraderie
 to finger their beads
 to drink from the cup of Saqi
Perhaps they even come to spin in ecstasy
 while the rest of the world sleeps
Mostly
They come to wait

While the simple wine boy weaves
 in and out of them
 invisible
Filling their cups
Lighting their smokes
All night long
He spins
 circles around them
Whirling
 like the grandest of dervishes
In his tattered robe

Even though in his heart of hearts
The boy knows
That it is his Robe
 that may catch the eye of his Beloved
 someday
It matters not
For his duty is to pour the wine
So he pours
And he waits

And each night when the moon has begun to set
 and the sun arise
He quietly gathers up the cups and debris
 left from a night of drunkeness
He carefully drinks down
 every drop of wine
 left in the bottom of the cups
 of the brotherhood
He sweeps the carpet of his Tavern
 and blows out the candles

It is time for sleep now
For this boy sleeps by day
 and waits by night
He slips out of his tattered robe
 folding it as though it were the robe of a king
 and lays it in the corner
 of the Tavern
Where it will rest
 until the next moonlit night

He curls up in the corner as well
 next to his Robe
The Robe of the Beggar
The Robe of the Fool
And as he sleeps
He dreams
Of the Rose of his Beloved's Heart

And while the wine boy dreams of Love
The Guest will come once again
 stealing into the shadows of the Tavern
Where He will secretly lay another scrap
 of the silk of His heart
 on top of the Tattered Robe
For the wine boy to sew
 into his beloved Coat of Ruin

I know nothing of the sun and moon
I know nothing of Your touch upon my heart
or of these tears of sorrow and joy
Long ago a black walnut tree tossed in
a summer storm
The wind swept the rain and the Truth
of Your Way over me
I knew nothing then
nothing now
Except one thing, Saqi
The knowing of a sweet sorrow
and of gratitude's faint whisper:
Patience.